Everyone Can Draw
FANTASY
FIGURES

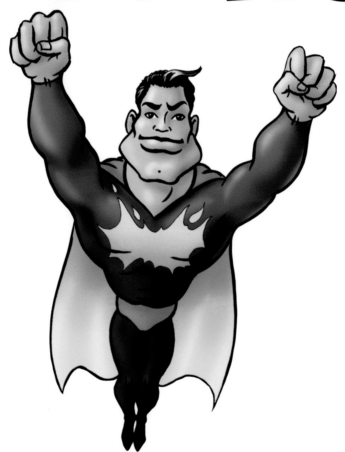

by Peter Gray

New York

Published in 2013 by Windmill Books, An Imprint of Rosen Publishing
29 East 21st Street, New York, NY 10010

Copyright © 2013 by Arcturus Publishing Ltd.

First Edition

Project Managers: Joe Harris and Anna Brett
Editor: Deborah Kespert
Illustrations: Peter Gray
Design: Picnic

Library of Congress Cataloging-in-Publication Data

Gray, Peter, 1969–
 Everyone can draw fantasy figures / by Peter Gray.
 p. cm. — (Everyone can draw)
 Includes index.
 ISBN 978-1-61533-507-7 (library binding)
 1. Fantasy in art. 2. Drawing—Technique. I. Title.
 NC825.F25G73 2013
 743.4—dc23
 2012003441

Printed in China

SL002239US

CPSIA Compliance Information: Batch # AS2102WM: For further information,
contact Windmill Books, New York, New York at 1-866-478-0556

CONTENTS

You Will Need...	4
Ready, Set, Go!	6
Girl Power	8
Superhero	12
Vile Vampire	14
Mad Scientist	18
Horrible Orc	20
Sea Witch	24
Elf Princess	26
Viking Warrior	28
Science Lab	30
Glossary, Further Reading, Websites, and Index	32

You Will Need...

Every artist needs essential drawing tools including pencils, pens, a ruler, paints, and paper. As you become more experienced, you can add materials such as ink pens, gouache paints, or pastel crayons. They will help you to develop your own favorite style.

PENCILS
Pencils come with different weights of lead. Hard lead pencils (#2 ½ to #4) are useful for drawing precise, fine lines. Soft lead pencils (#1 to #2) work well for shading and softer lines.

MARKER PENS
Before coloring in, it's a good idea to go over your pencil outline. A marker pen is perfect for this and you can use a thick or thin one depending on the effect you want to create.

PAPER
You can use different types of paper for different jobs. When practicing shapes and lines, a rough sketch paper is practical. For final colored-up drawings, a smooth plain paper works well.

RULER
For technical drawings, a ruler really helps. It will allow you to make your lines straight and angles accurate.

ERASER
From time to time, you'll make mistakes or need to remove guidelines. That's where an eraser comes in handy. Don't worry if you make mistakes. Everybody does!

PAINTS

There are all different kinds of paints you can experiment with but poster paints and watercolors are an excellent starting point. You could also try gouache, which will give you more solid tones.

FELT-TIP PENS

Felt-tips are perfect for coloring drawings that need bold, bright colors. They work especially well for cartoons.

ART IN ACTION

Take a look at the examples below to see how to get the best out of using different pens, brushes, and paints.

This gruesome vampire was colored in watercolor paints. Colors can be blended together to create different shades with watercolors.

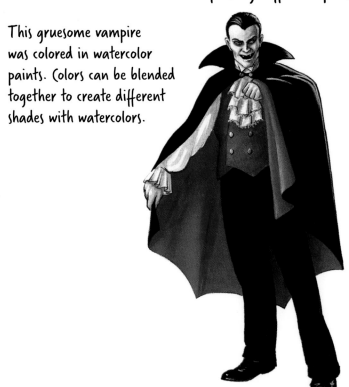

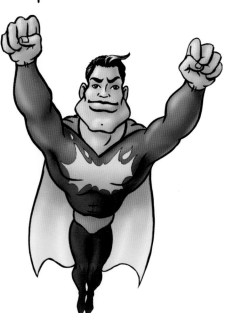

Felt-tip pens were used to color this cartoon superhero, making him stand out. The outline was done with a fine black marker pen.

Ready, Set, Go!

Do you like drawing fantasy characters? Then, this book is perfect for you because it's packed full of ideas and inspiration to help you create superheroes, elves, warriors, and much more. Whether you want to improve your skills or pick up some tips, just dive in!

STYLES

You'll find two different styles of art in this book. There are realistic drawings where your goal is to make the picture look natural and there are also fun cartoon drawings.

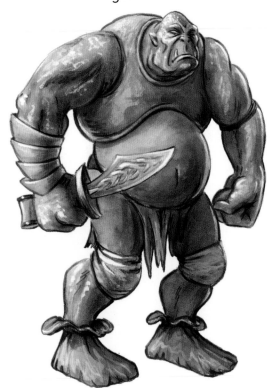

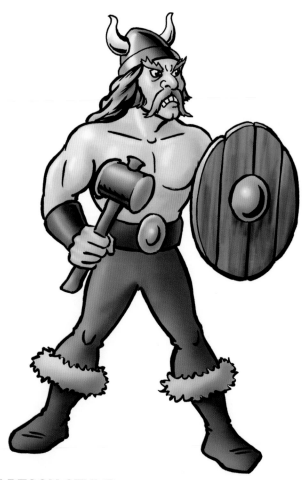

REALISTIC STYLE
This horrible orc is drawn and colored in a realistic style with watercolor paints. Paying attention to detail and looking for references to copy helps with realistic drawings.

CARTOON STYLE
This Viking warrior is drawn and colored in a cartoon style. The features are exaggerated and there is a thick black outline. Cartoon drawings allow you to experiment with shapes and colors.

FOLLOW THE LINES

Build up your picture step-by-step by looking at the color of each stroke. Red strokes show you the lines you need to draw and black strokes show what you have already drawn. All the lines will be red in the first step. After that only the new lines will be in red.

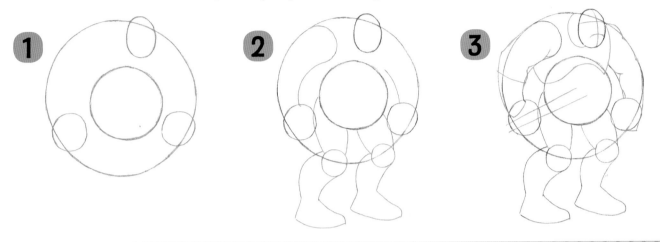

COLOR MAGIC

When you color your drawings, you instantly bring them to life. You can work with colors that go well together and also those that contrast.

If you're going for realistic hair, then it's a good idea to avoid a single block of color. Brown, yellow, black, and white have all been blended together here.

To give this elf a true woodland feel, we decided to color her outfit entirely in different shades of green.

We have used light skin tones for the elf's flesh to fit in with the shady place where she lives.

Girl Power

Get ready for action and sketch this female superhero! With a superhero, the secret is to exaggerate the proportions of a human figure. Follow the steps to find out how.

1 Start with three ovals for the head, chest, and hips. Copy the picture carefully. Mark guidelines on the face and chest. Then add a sloping line for the shoulders.

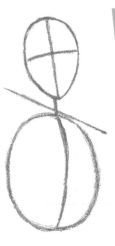

2 Next draw stick legs and arms, paying attention to where they bend. Include dots for the joints. Notice how one leg is shorter. This will be the front, raised leg. The hands and feet can be oval shapes.

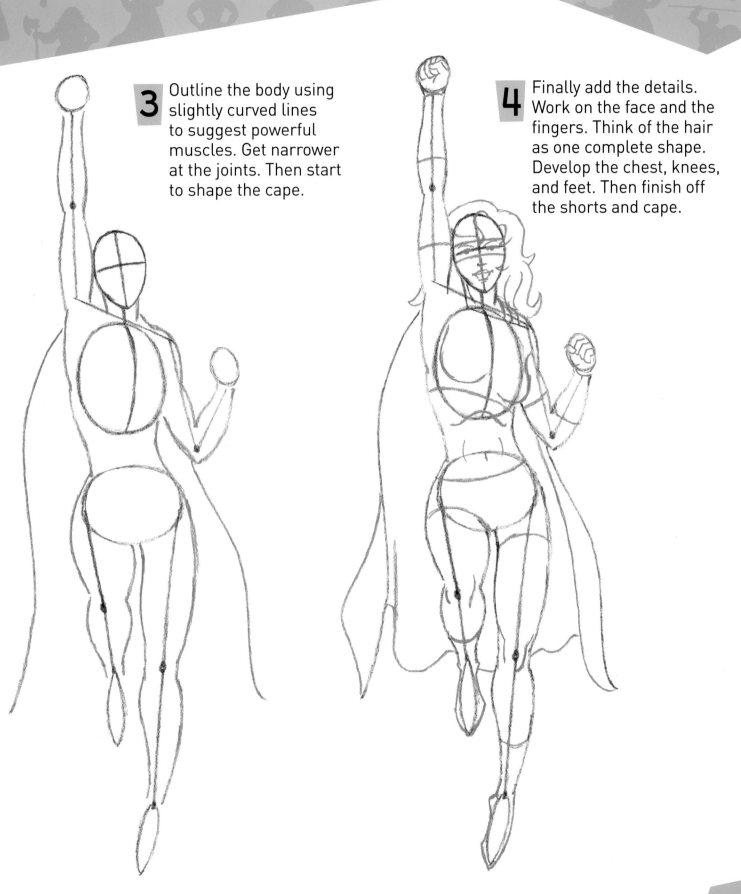

3 Outline the body using slightly curved lines to suggest powerful muscles. Get narrower at the joints. Then start to shape the cape.

4 Finally add the details. Work on the face and the fingers. Think of the hair as one complete shape. Develop the chest, knees, and feet. Then finish off the shorts and cape.

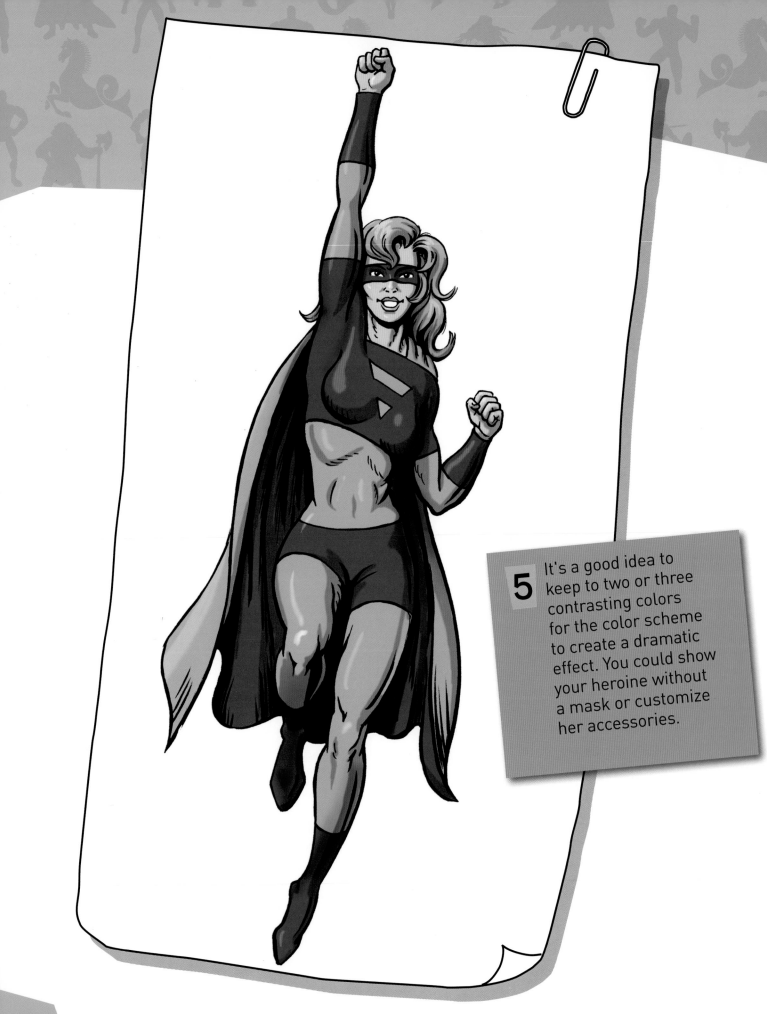

5 It's a good idea to keep to two or three contrasting colors for the color scheme to create a dramatic effect. You could show your heroine without a mask or customize her accessories.

Drawing hands is a challenge, so make sure you take your time.
Keep on practicing until you get them right.

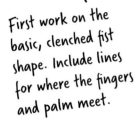

First work on the basic, clenched fist shape. Include lines for where the fingers and palm meet.

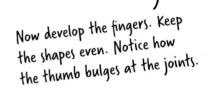

Now develop the fingers. Keep the shapes even. Notice how the thumb bulges at the joints.

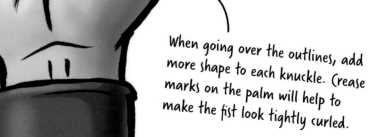

When going over the outlines, add more shape to each knuckle. Crease marks on the palm will help to make the fist look tightly curled.

Superhero

In this cartoon drawing, you're going to make the details in the foreground bigger so it looks as if your action hero is flying off the page straight toward you.

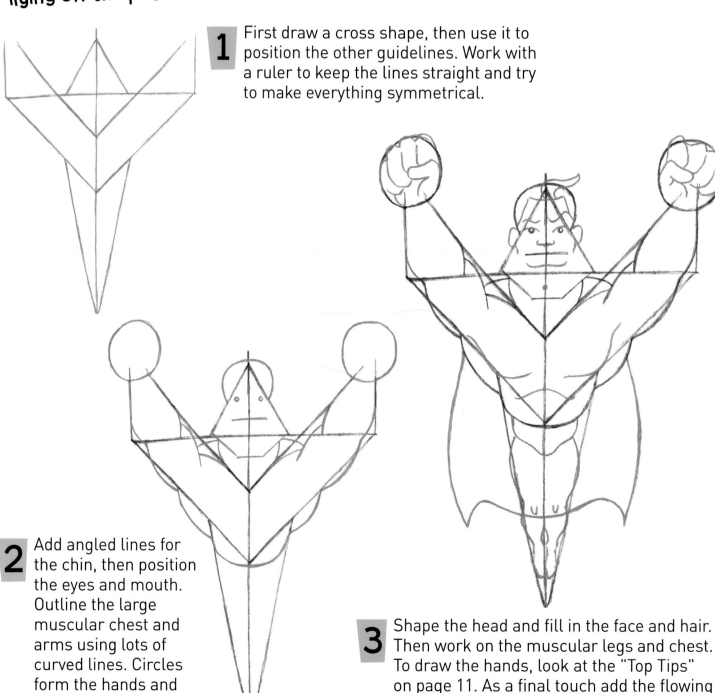

1 First draw a cross shape, then use it to position the other guidelines. Work with a ruler to keep the lines straight and try to make everything symmetrical.

2 Add angled lines for the chin, then position the eyes and mouth. Outline the large muscular chest and arms using lots of curved lines. Circles form the hands and domed head.

3 Shape the head and fill in the face and hair. Then work on the muscular legs and chest. To draw the hands, look at the "Top Tips" on page 11. As a final touch add the flowing cape. Erase your guides.

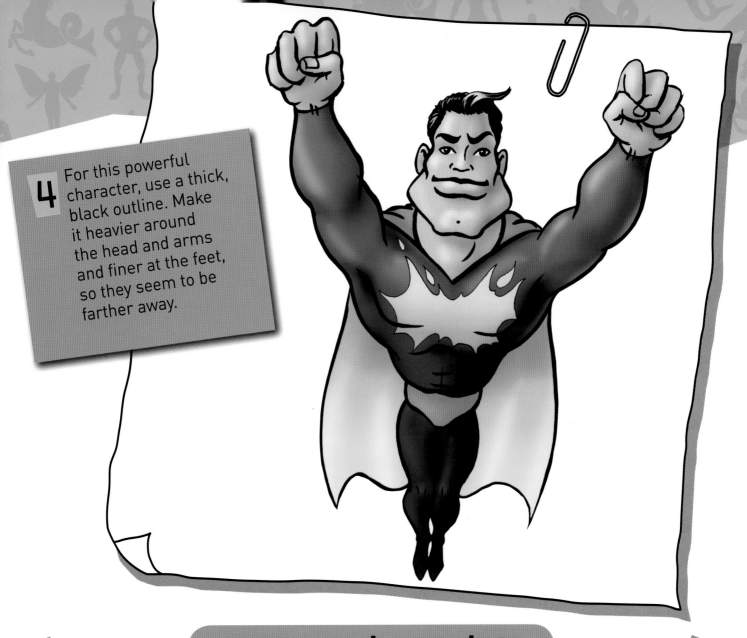

4 For this powerful character, use a thick, black outline. Make it heavier around the head and arms and finer at the feet, so they seem to be farther away.

CARTOON CORNER

Now try drawing these mini superheroes or invent your own!

1

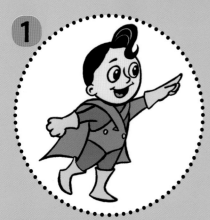

What special powers do you think this colorful superboy has?

2

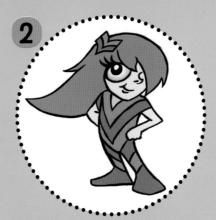

Big hair, stripes, and a giant eye make this all-action girl stand out.

3

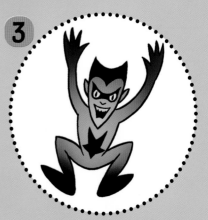

A green face and yellow eyes can make your character look wicked!

Vile Vampire

Watch out for this bloodsucking vampire. He's not the friendly kind! Give him a deathly pale face and a swishing blood-red cape to make him seem really creepy.

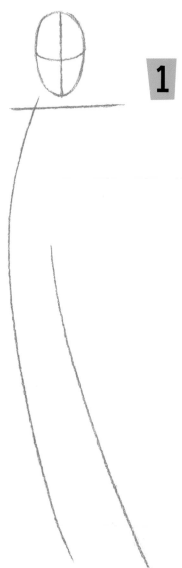

1 Start with two long curves to capture the vampire's overall pose and position of his legs. Mark a line for his shoulders. Then draw the head and add the guides.

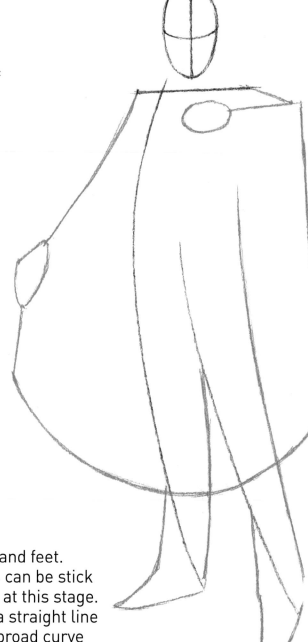

2 Shape the long legs and feet. The arms and hands can be stick lines ending in ovals at this stage. Form the cape with a straight line from the arm and a broad curve at the bottom.

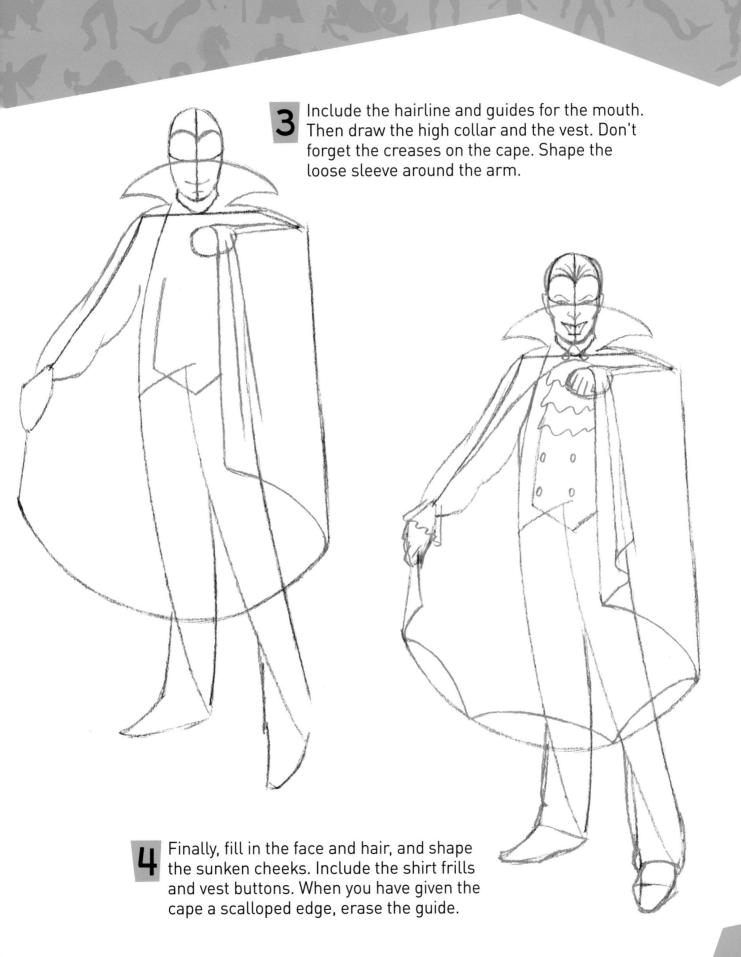

3 Include the hairline and guides for the mouth. Then draw the high collar and the vest. Don't forget the creases on the cape. Shape the loose sleeve around the arm.

4 Finally, fill in the face and hair, and shape the sunken cheeks. Include the shirt frills and vest buttons. When you have given the cape a scalloped edge, erase the guide.

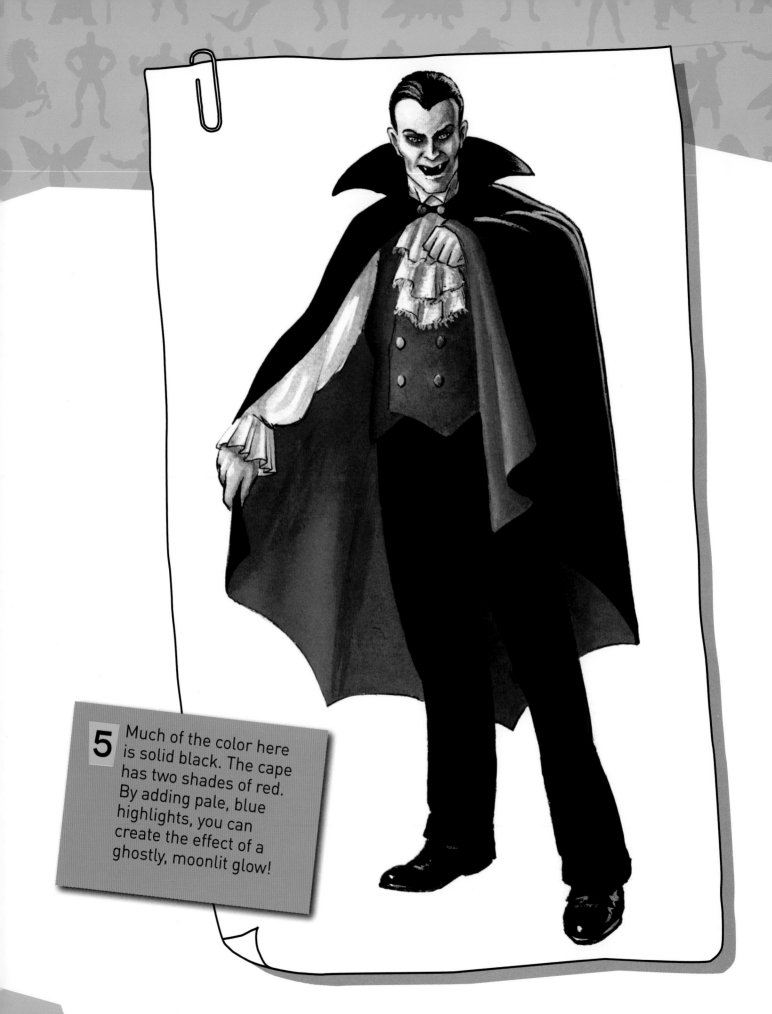

5 Much of the color here is solid black. The cape has two shades of red. By adding pale, blue highlights, you can create the effect of a ghostly, moonlit glow!

TOP TIPS

To capture a vampire's hypnoptic character, you need to spend time on the face details.

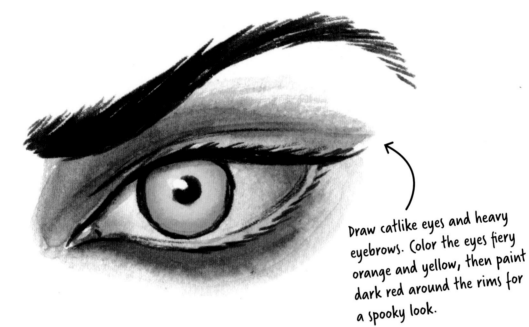

Draw catlike eyes and heavy eyebrows. Color the eyes fiery orange and yellow, then paint dark red around the rims for a spooky look.

Make the lips pale so that the teeth and sharp fangs stand out. The fangs should be pointed and slightly curved. Add dirty yellow to suggest decay.

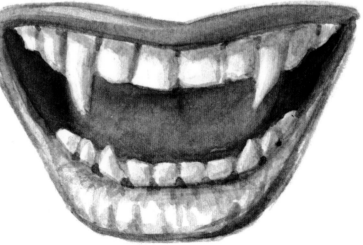

Mad Scientist

Yikes! What is this crazy cartoon scientist inventing this time? What's bubbling in his lab? Once you've mastered him mixing his chemicals, try drawing the explosion that happens next!

1 Draw two overlapping circles, one large and one small, for the big head. Then add a guideline down the center. A cone shape forms the body.

2 Next, copy the arms and legs. They are made up of simple lines and shapes and should be easy to draw. Outline the massive hair and the pointed hairline.

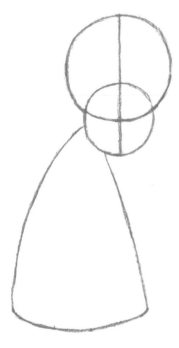

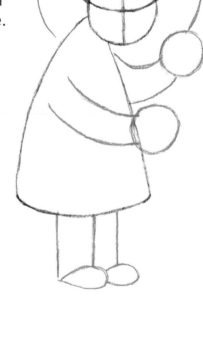

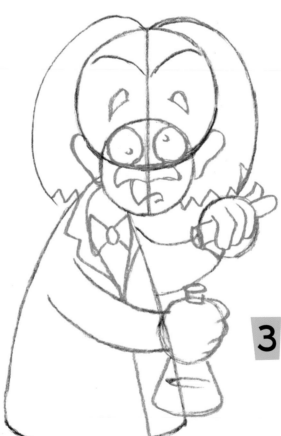

3 All that's left is to fill in the details. When working on the face, draw most of the features inside the smaller circle so that the bulging forehead looks huge. Keep the clothing simple and don't forget the equipment.

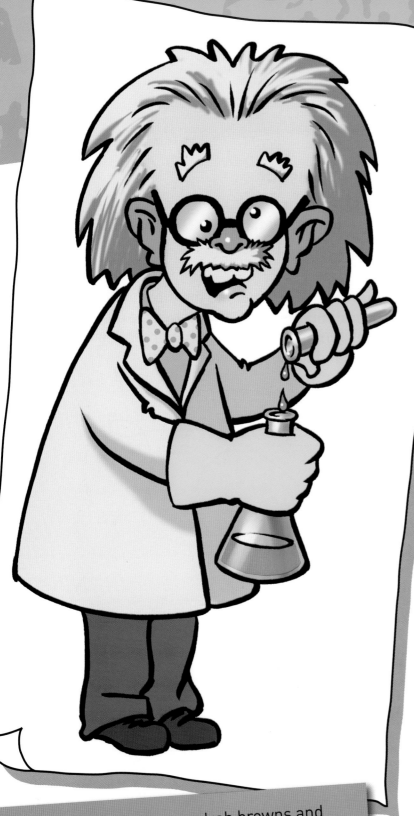

4 When coloring in, use drab browns and grays for the scientist's hair and most of his clothing. Contrast this with wacky, yellow gloves and toxic pink and lime green chemicals.

A crazy scientist needs some crazy equipment! Why not bring his lab to life as well?

A red face with puffed-out cheeks and scrunched up eyes makes this flask seem ready to explode at any moment.

This test tube is on the loose. Give it waving stick arms, running legs, and a big smile. A few drops spilling out of the top help, too.

Horrible Orc

Orcs are fierce humanoid monsters with grotesque features. In this drawing, your goal is to capture the orc's bulky shape and his mean, but stupid expression.

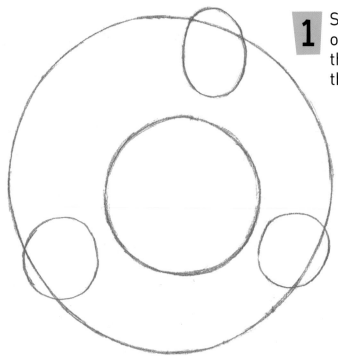

1 Start with a large circle for the shoulders and overall body shape. Another circle inside forms the stomach and three smaller circles mark the hands and the head.

2 On the bottom edge of the largest circle, draw two more circles for the knees and add lines for the powerful legs and large feet. Start to draw the arms.

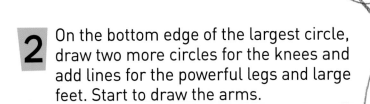

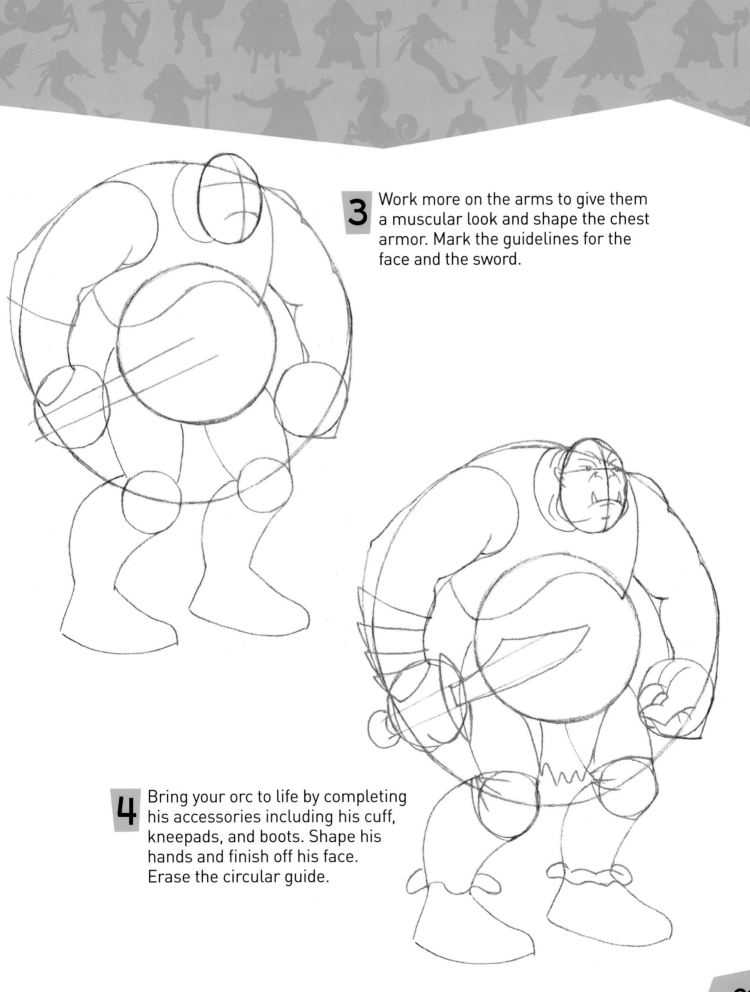

3 Work more on the arms to give them a muscular look and shape the chest armor. Mark the guidelines for the face and the sword.

4 Bring your orc to life by completing his accessories including his cuff, kneepads, and boots. Shape his hands and finish off his face. Erase the circular guide.

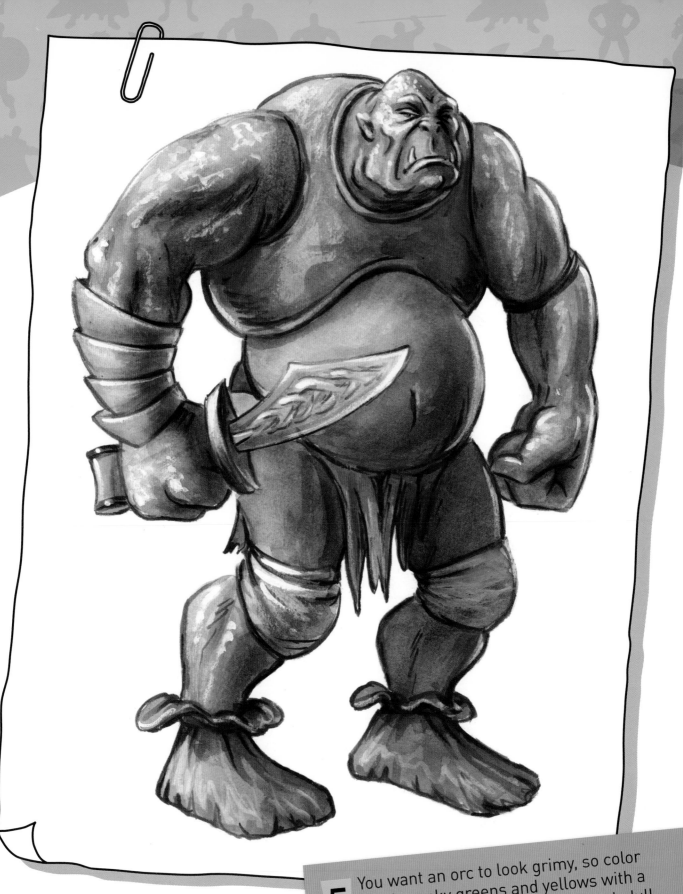

5 You want an orc to look grimy, so color him in yucky greens and yellows with a hint of purple. Make his armor look dull, too, with different shades of brown.

Follow these tips to add the finishing touches to your beast.

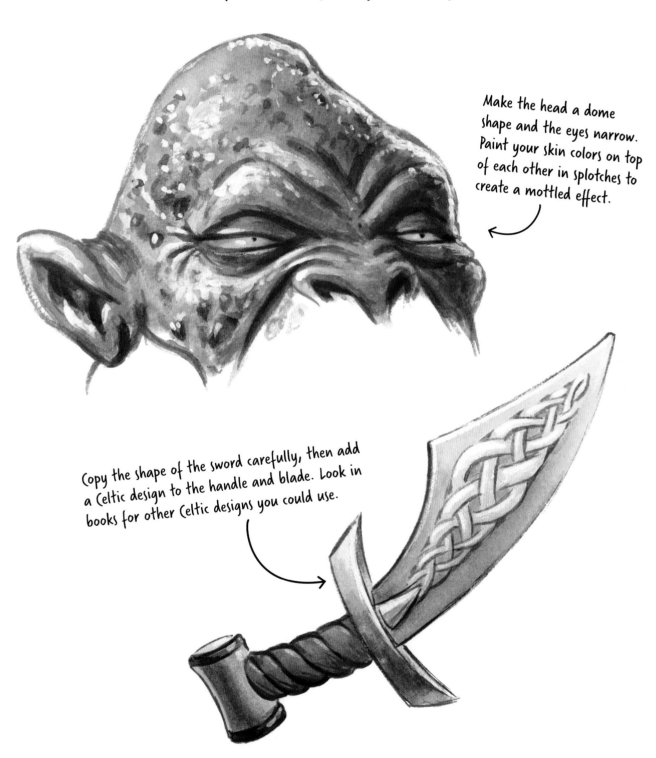

Make the head a dome shape and the eyes narrow. Paint your skin colors on top of each other in splotches to create a mottled effect.

Copy the shape of the sword carefully, then add a Celtic design to the handle and blade. Look in books for other Celtic designs you could use.

Sea Witch

In folklore, sea witches had power over the waves. When drawing this wicked-looking creature, remember that her top half is human and her bottom half serpent.

1 Draw three basic shapes—a small circle for the head, an oval for the chest, and a large circle for the serpent body. Then add guidelines for the shoulders and arms.

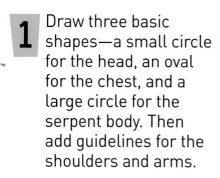

2 When shaping the arms and shoulders, spend time on the muscles. Work on the body and tail following the curve of the circle. Outline the face and add the trident.

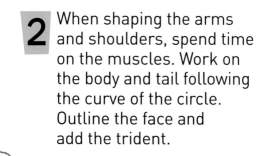

3 Shape the body and tail further. Give the sea witch a seashell helmet and top, and flowing hair. Then add her face. Finish off the hands and the trident. Erase the circular guide.

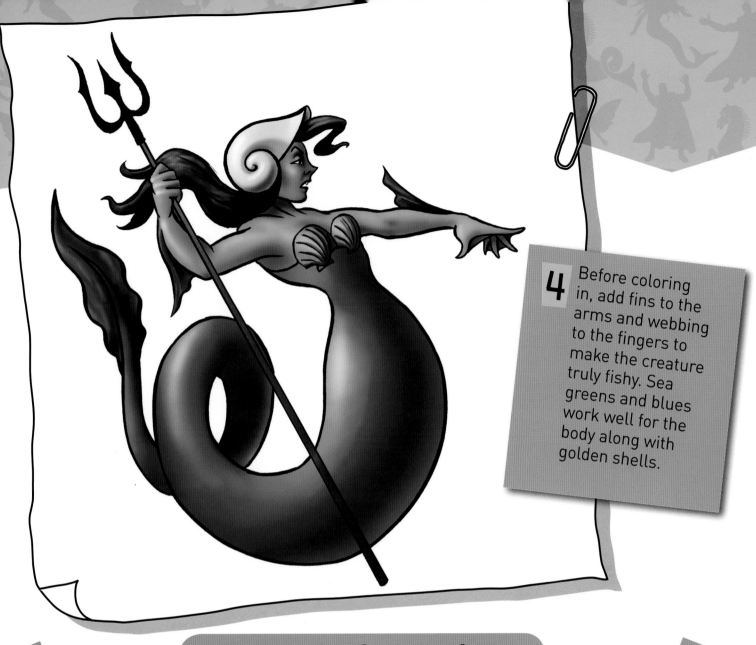

4 Before coloring in, add fins to the arms and webbing to the fingers to make the creature truly fishy. Sea greens and blues work well for the body along with golden shells.

CARTOON CORNER

Draw and color a seahorse chariot for your wicked witch in three simple steps.

1

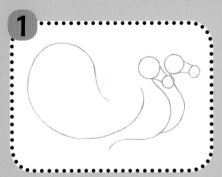

Form the seahorses using curved lines for the bodies and circles for the heads. Work on the one nearest to you first. Then shape the chariot.

2

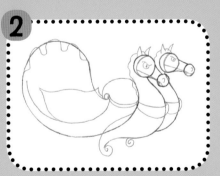

Add the reins to the seahorses and draw their face details. Finish off their curly tails. Scallop the edge of the chariot and draw the cushion.

3

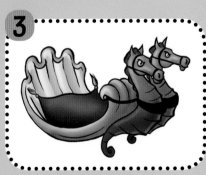

You can add more detail at the inking stage, such as ridges on the seahorses' bodies. Make the inside of the chariot golden yellow.

Elf Princess

Make this elfin princess with pointed ears look tall and elegant rather than strong and powerful. Use lots of long flowing curved lines to achieve this graceful effect.

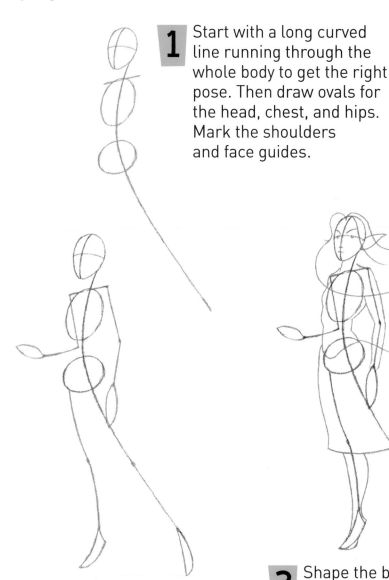

1 Start with a long curved line running through the whole body to get the right pose. Then draw ovals for the head, chest, and hips. Mark the shoulders and face guides.

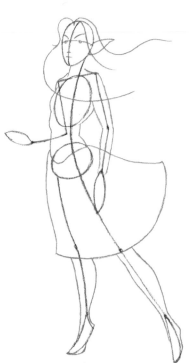

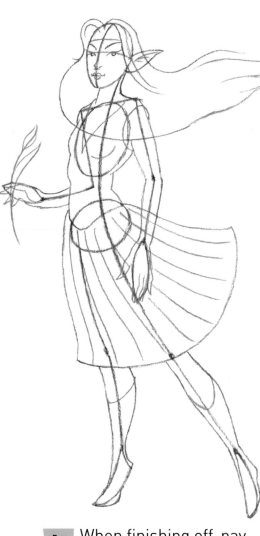

2 Add dots for the knees, and a guideline for the front leg. The feet can be simple shapes for now. Position the arms and hands, paying attention to the angles.

3 Shape the body, starting with the chest and arm. A bell shape forms the skirt. Below, draw the legs and boots. Add pointed ears and flowing hair. Mark the facial features.

4 When finishing off, pay attention to the face and hands. Make the fingers long and thin. Complete the costume including the pleated skirt, and work on the face and hair. Add a flower as a final touch.

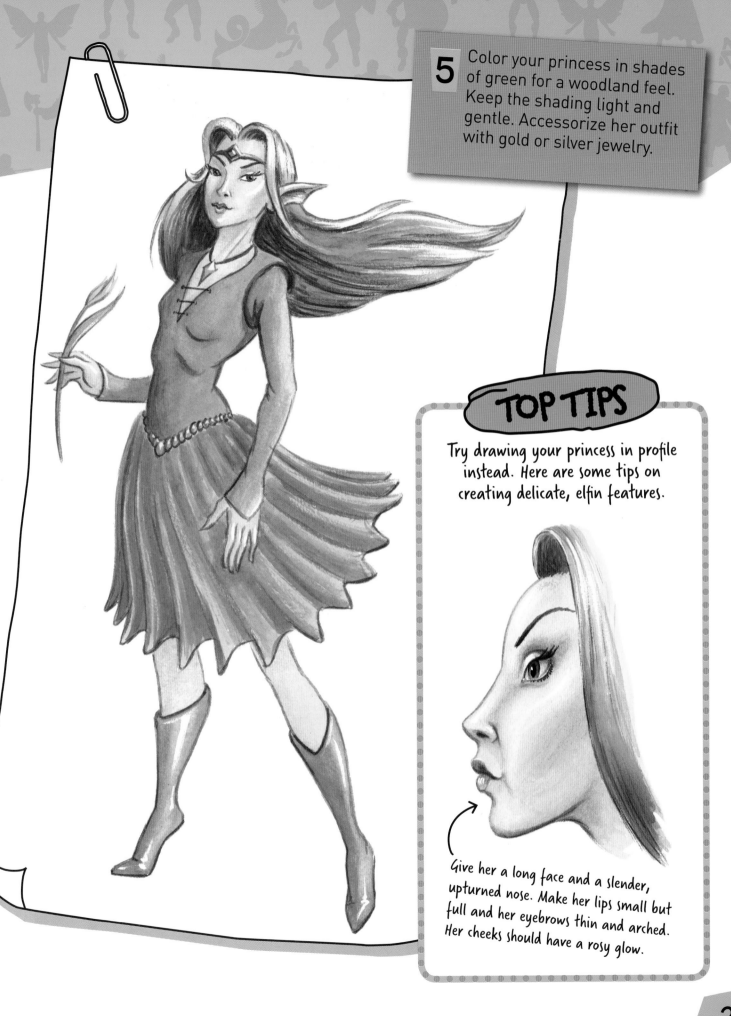

5 Color your princess in shades of green for a woodland feel. Keep the shading light and gentle. Accessorize her outfit with gold or silver jewelry.

TOP TIPS

Try drawing your princess in profile instead. Here are some tips on creating delicate, elfin features.

Give her a long face and a slender, upturned nose. Make her lips small but full and her eyebrows thin and arched. Her cheeks should have a rosy glow.

Viking Warrior

This fantasy Viking warrior is fierce and strong. You can capture this attitude by giving him a broad body and setting his muscular legs wide apart in a fighting stance.

1 First draw a large "X" shape. Using this as your guide, position a box for the body and a circle for the head. Then add guidelines for one arm ending in an oval for the hand.

2 Next outline the body, making sure that the arms and legs look muscular. Mark the knee joints and the face guides. Start the shield.

3 You should now have enough form to add the details easily. Copy the picture or make up your own face, costume, and weapons. Just remember to make your warrior look dangerous!

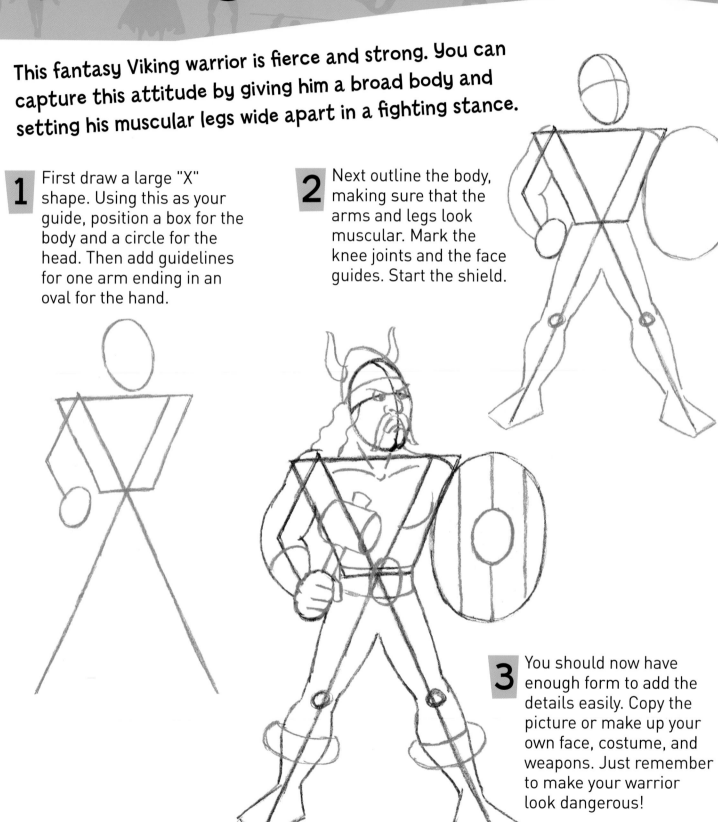

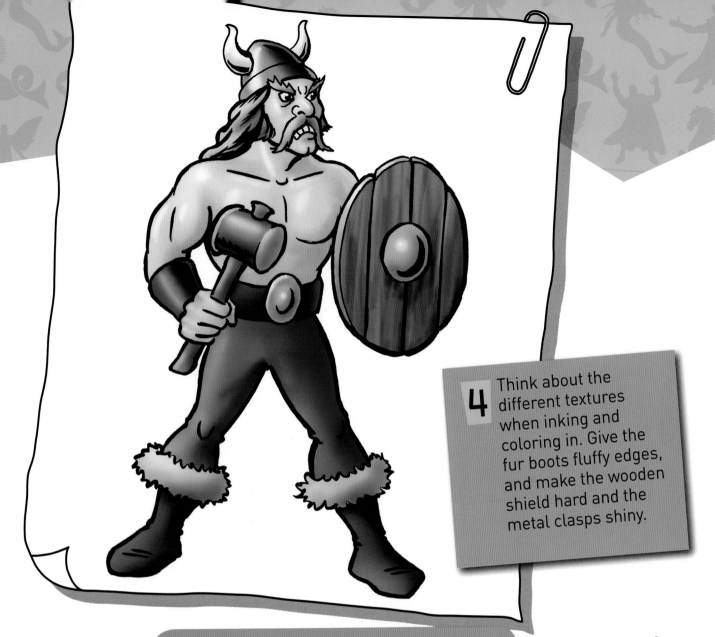

4 Think about the different textures when inking and coloring in. Give the fur boots fluffy edges, and make the wooden shield hard and the metal clasps shiny.

CARTOON CORNER

Different warriors need different helmets. Check out these designs.

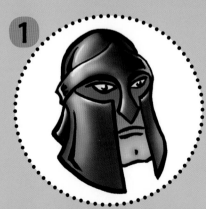

1

A full face protector makes this Spartan warrior really scary. It also makes his eyes stand out.

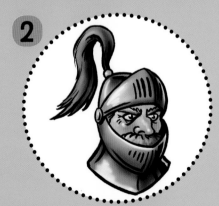

2

This knight's helmet is more decorative. Make the metal shine with white highlights and add brass clips.

3

How about creating a Roman centurion? Check out history books for more picture references.

SCIENCE LAB

The mad scientist you drew (pages 18–19) needs his own lab to experiment in! Try copying this picture, using the hints and tips to bring the cartoon scene to life.

1 Get creative with your cartoon picture. Who's to say that a test tube or a bunsen burner shouldn't have a face?!

2 Add a ceiling in a different color so it looks as if the scientist is inside a room.

3 Don't forget to include shadows under the shelves to make them seem real and solid.

4 Try giving objects arms and legs to add some action to the scene.

5 Leaving lots of space around a character helps him or her to stand out.

6 Set tools and objects at angles to make the picture more interesting.

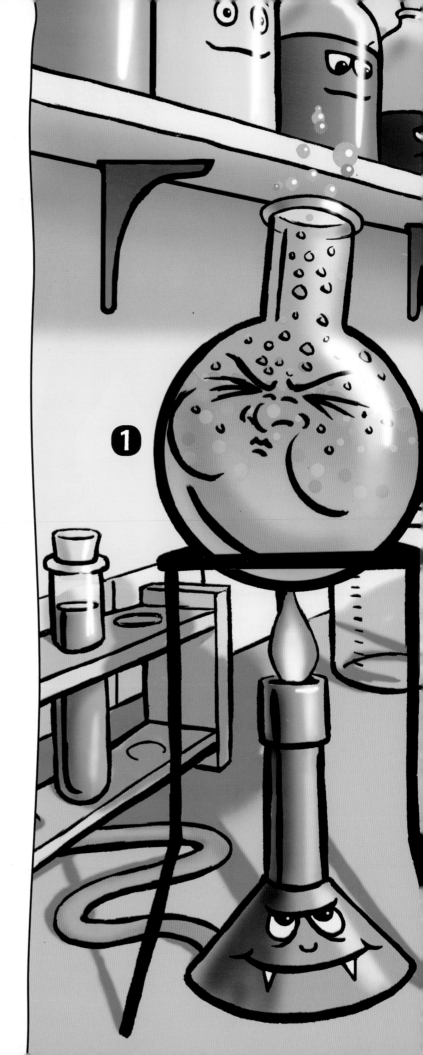

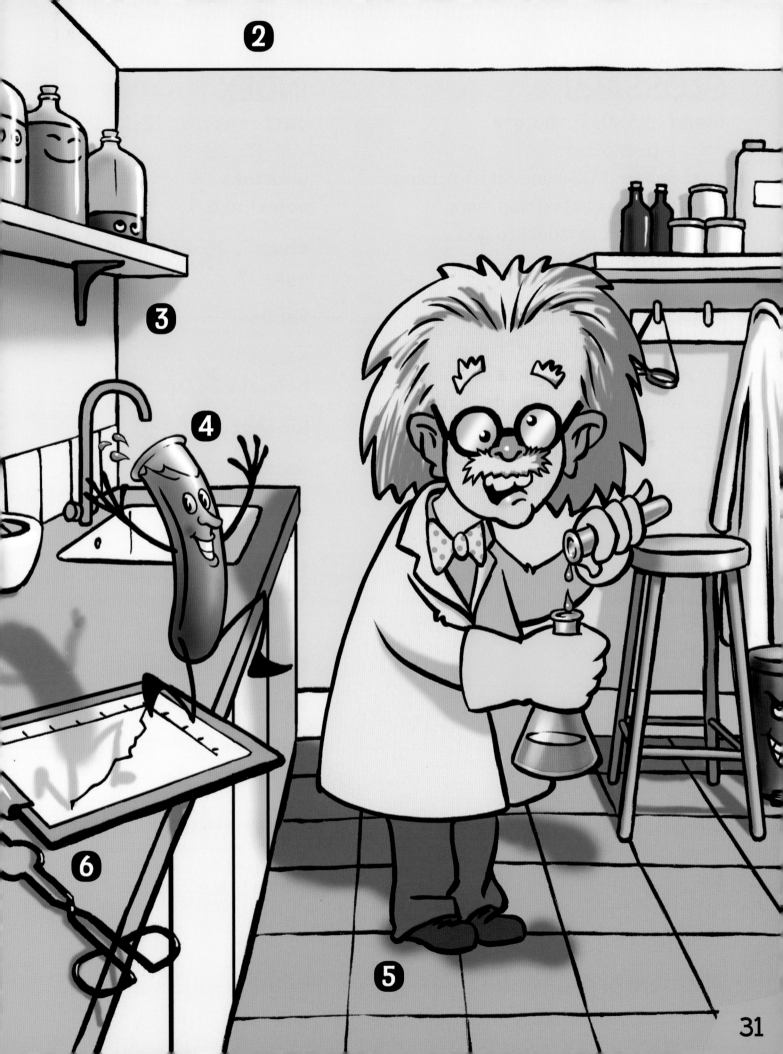

GLOSSARY

blend (BLEND) To mix one color into another.

customize (KUS-tuh-myz) To change things to make something more individual and personal to you.

guideline (GYD-lyn) A pencil line to help you shape your drawing, which you then erase.

highlights (HY-lyts) White areas that help to make a drawing look solid and emphasize its shape.

scalloped (SKAH-lupd) Having an edge with curves like a scallop shell.

shade (SHAYD) To make an area of a picture darker.

symmetrical (sih-MEH-trih-kul) Having an exact match on either side of a line.

watercolors (WAH-ter-kuh-lerz) Water-based paints that are useful for blending colors.

INDEX

cartoons 5–6, 12–13, 18–19, 24–25, 28–31
chariots 25
coloring 5, 7

elves 7, 26–27
eyes 17, 23

fangs 17

hands 11
helmets 24, 29

laboratory 30–31

orcs 6, 20–23

scientists 18–19, 30–31
shields 28–29
superheroes 5, 8–13
swords 21, 23

test tubes 19, 30–31
tridents 24–25

vampires 5, 14–17

warriors 6, 28–29
witches 24–25

FURTHER READING

Ames, Lee J., and Andy Mitchell. *Draw 50 Magical Creatures*. New York: Watson-Guptill, 2009.
Bergin, Mark. *How to Draw Fantasy Art*. How to Draw. New York: PowerKids Press, 2011.
Hart, Christopher. *Kids Draw Angels, Elves, Fairies, & More*. New York: Watson-Guptill, 2001.
Stephens, Jay. *Heroes! Draw Your Own Superheroes, Gadget Geeks & Other Do-Gooders*. Asheville, NC: Lark Books, 2007.

WEBSITES

For web resources related to the subject of this book, go to: **www.windmillbooks.com/weblinks** and select this book's title.